Seasonal Vegetables
A Still Life Coloring Book

Illustrations by
Sue-Jen Song

Copyright ©2018 by Sue-Jen Song
All rights reserved.

ISBN: 9781790343737
First Edition

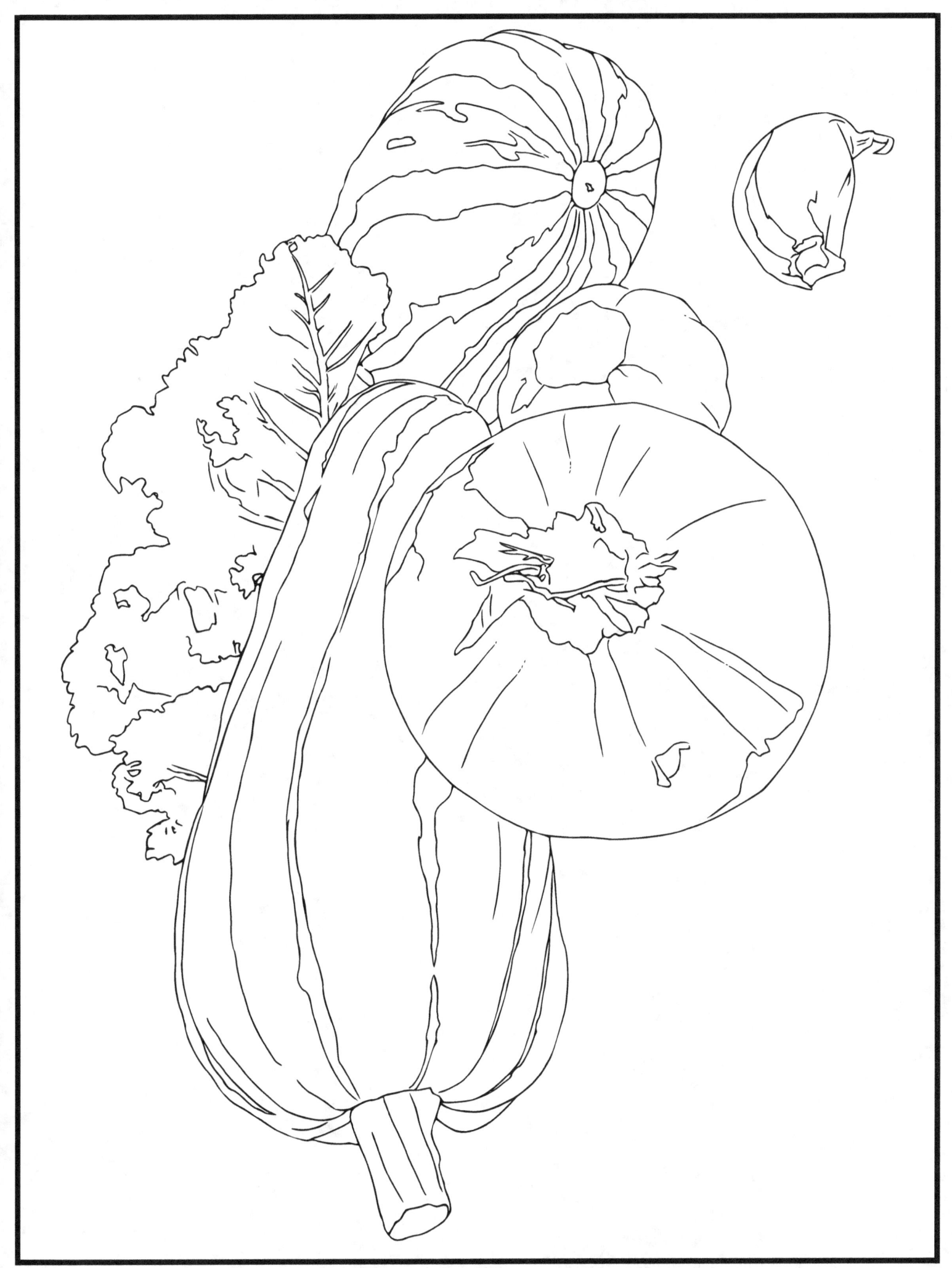

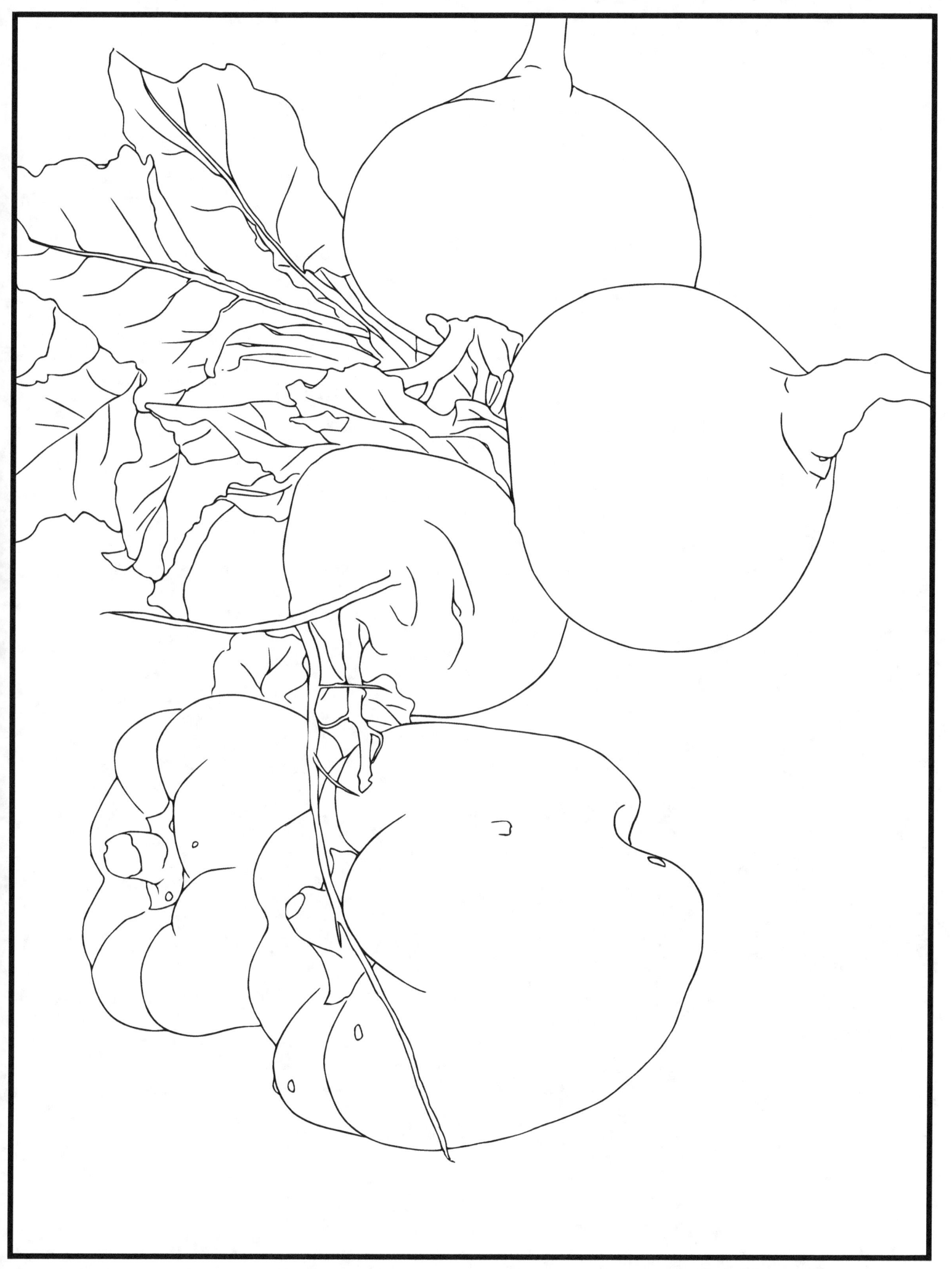

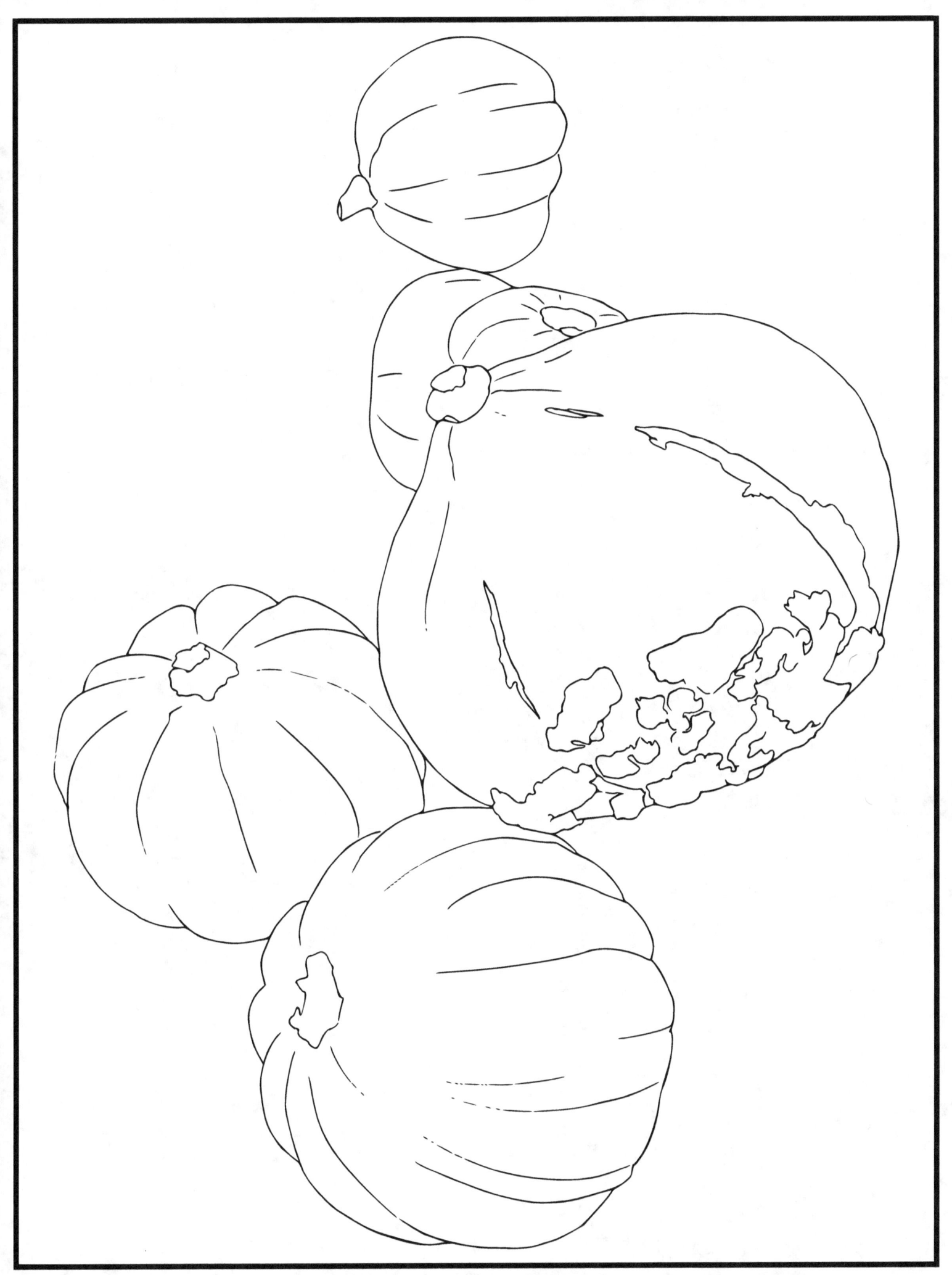

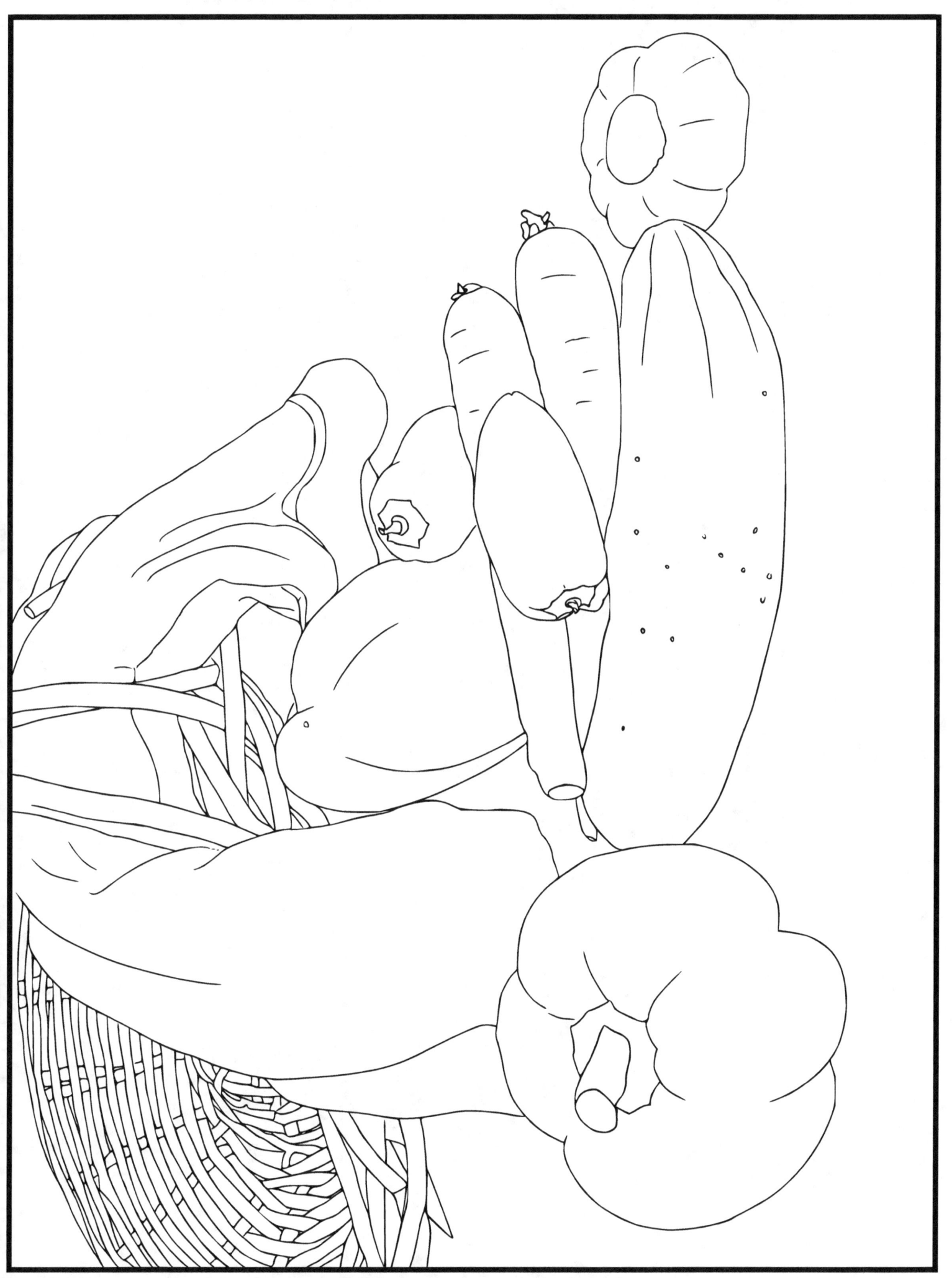

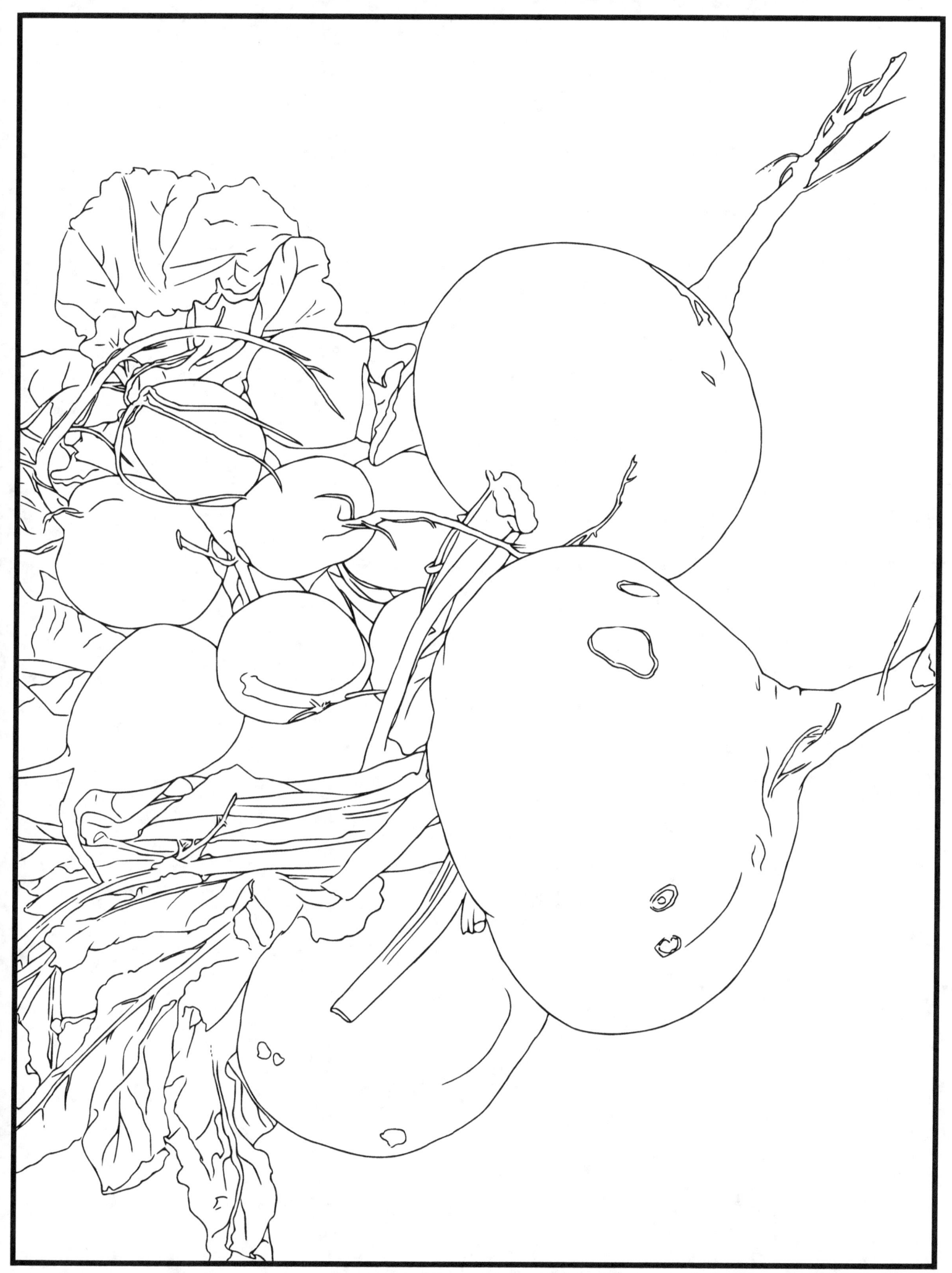

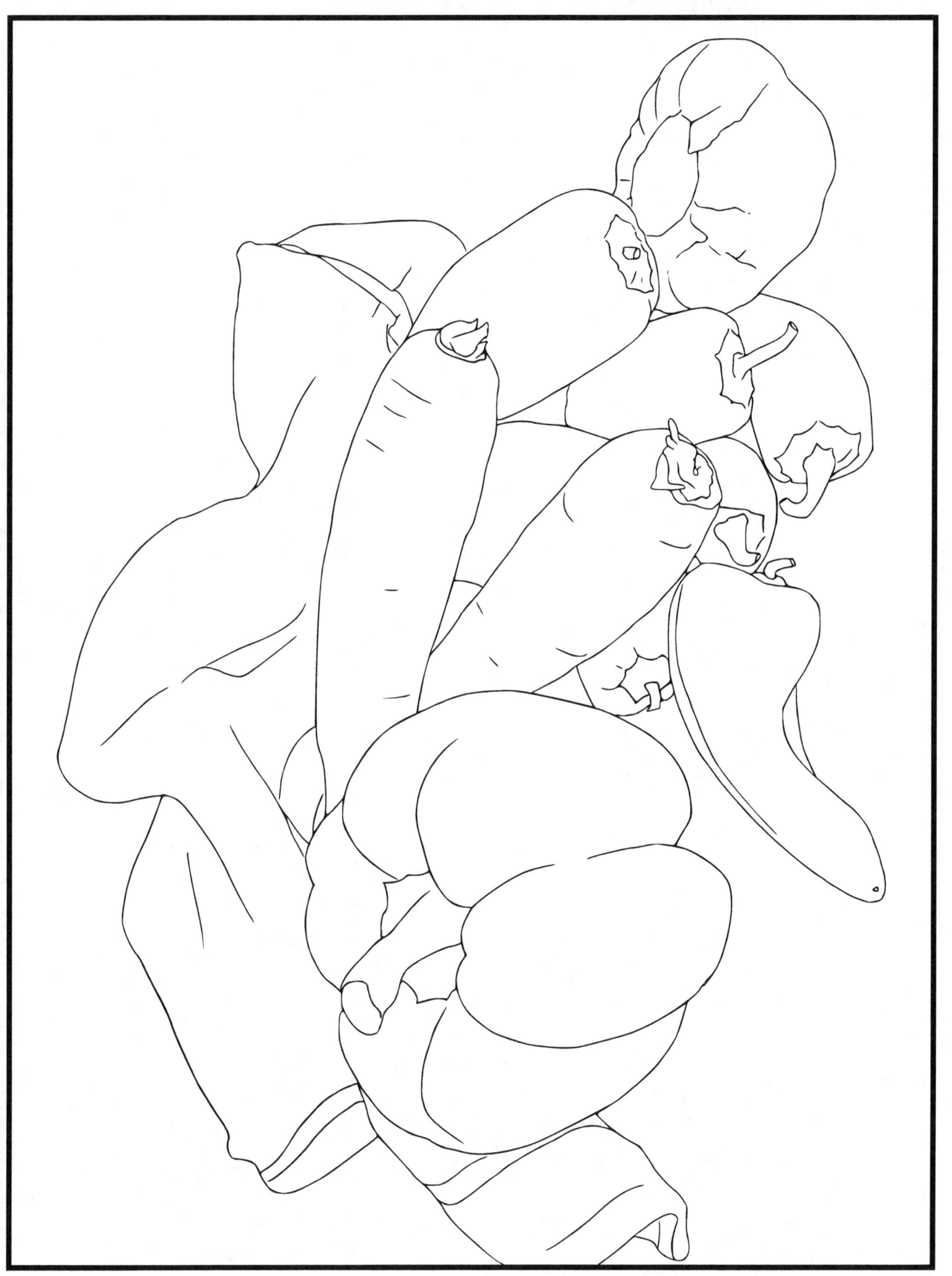

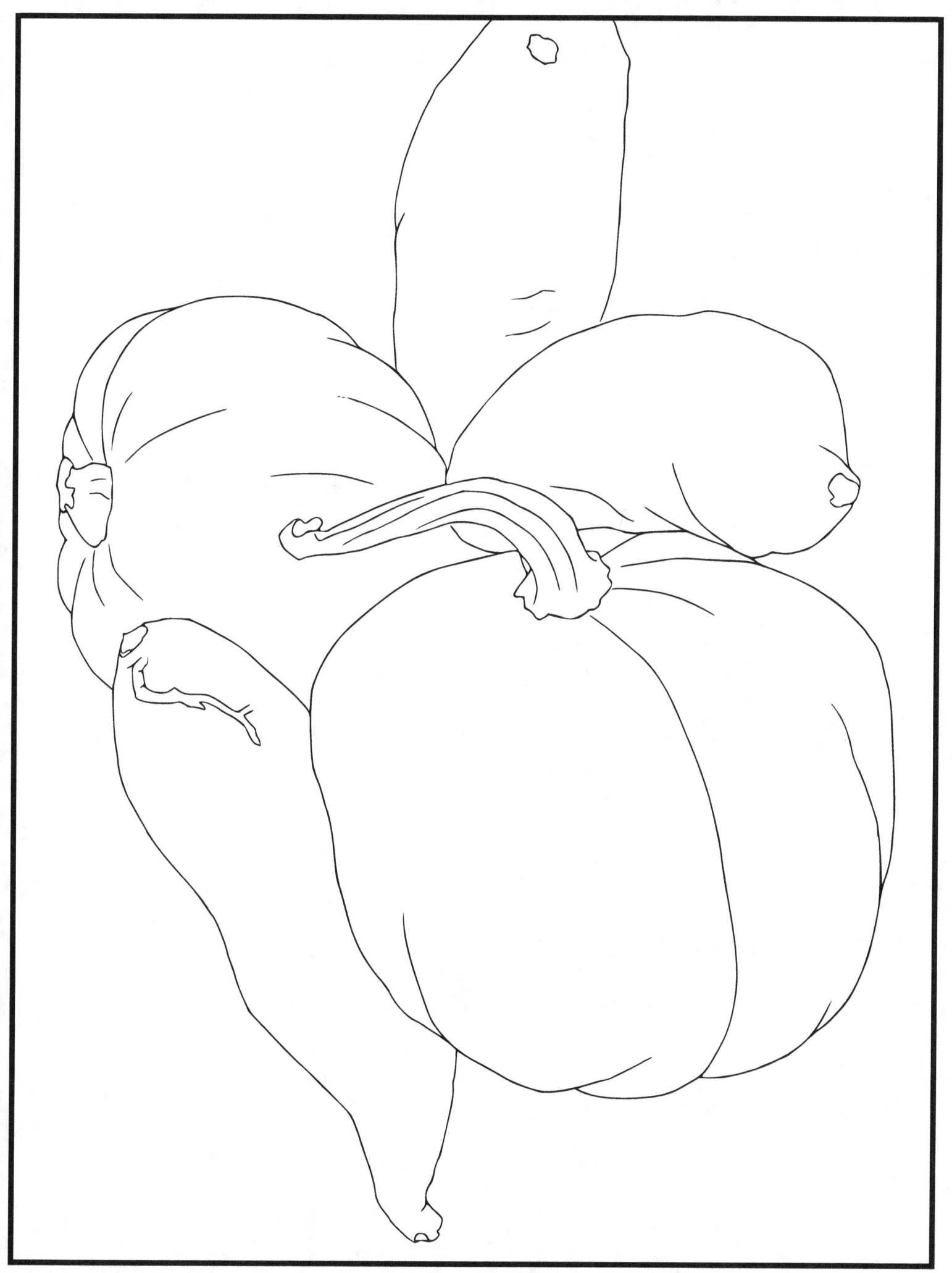

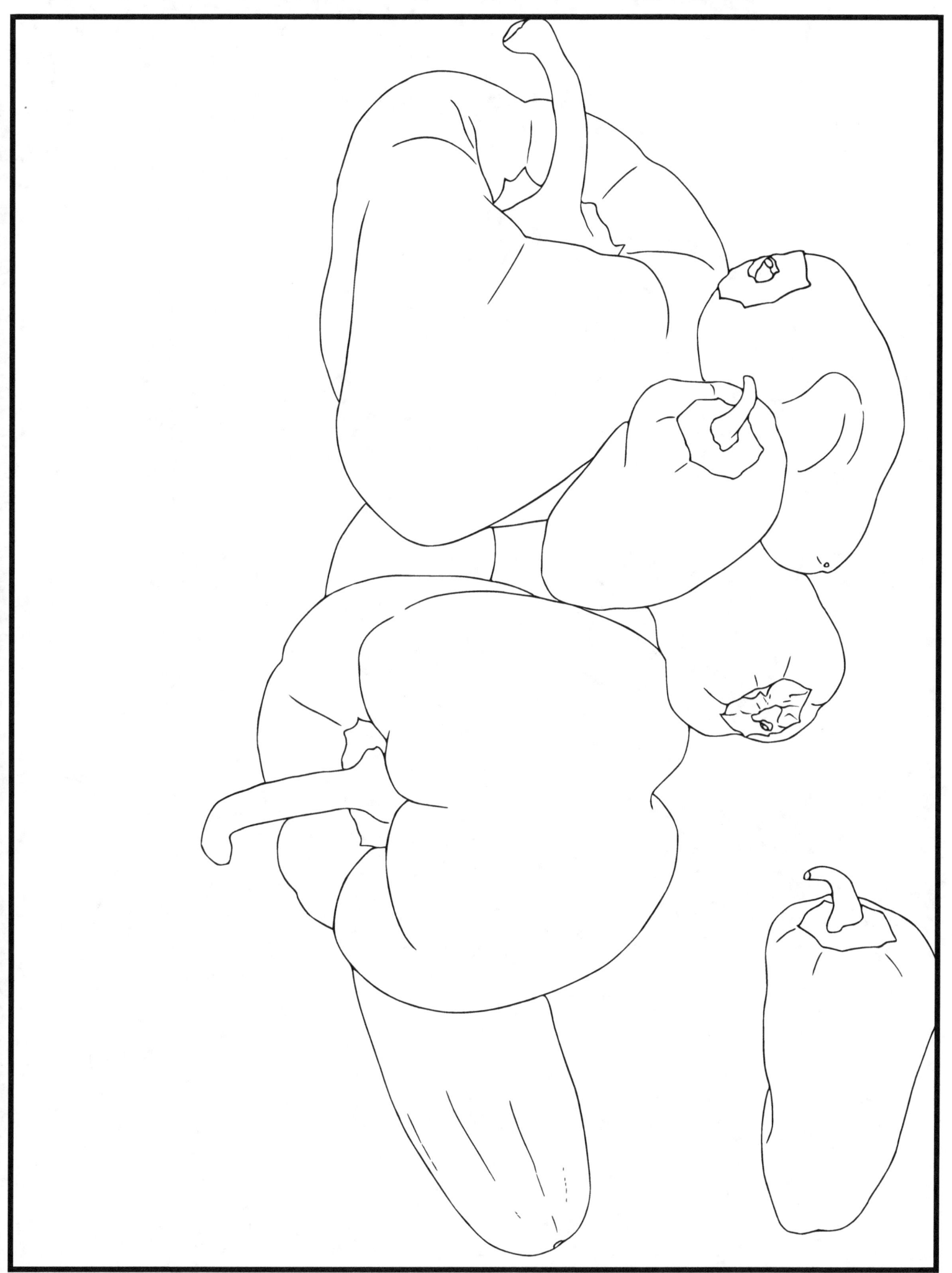

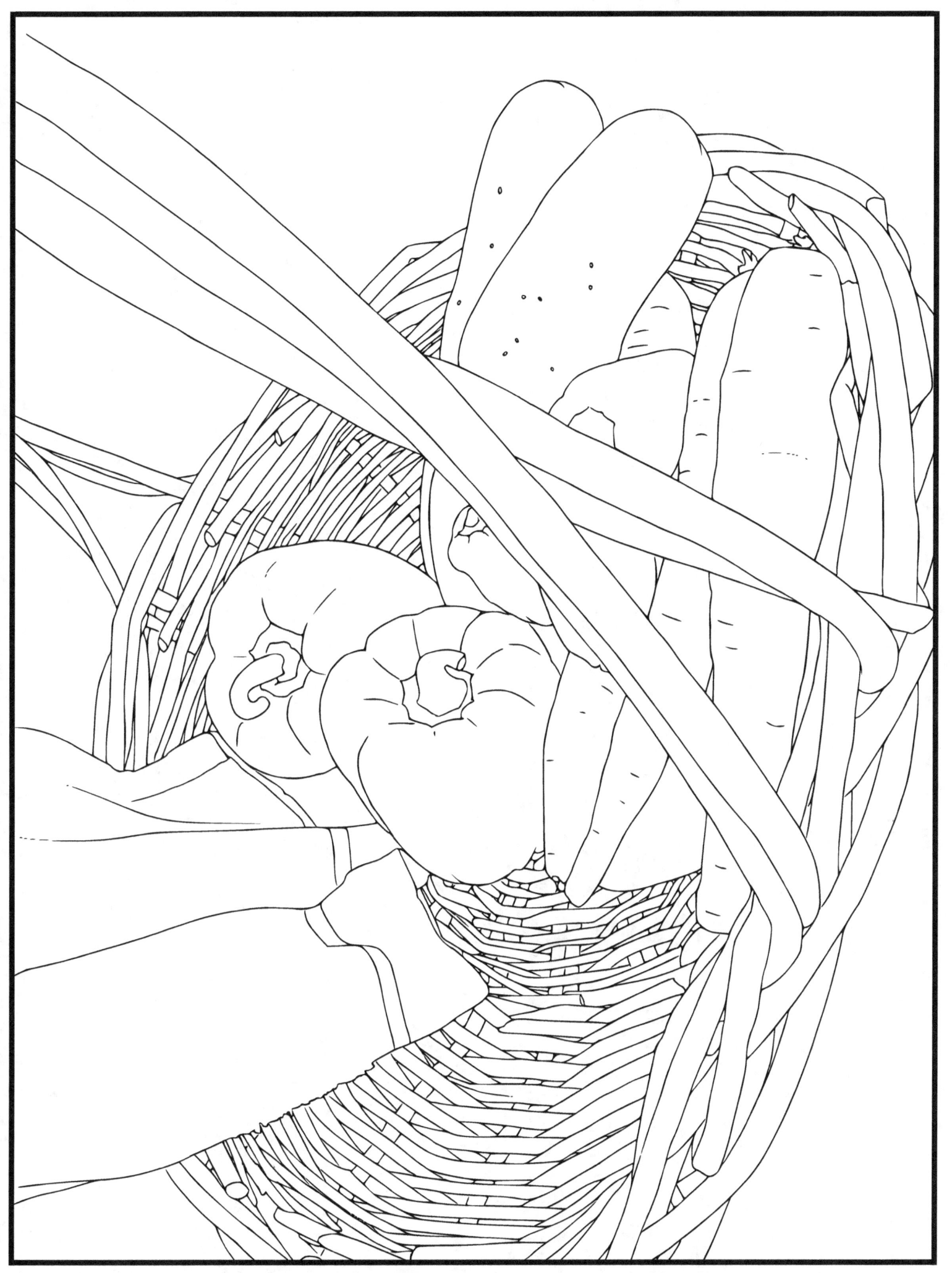

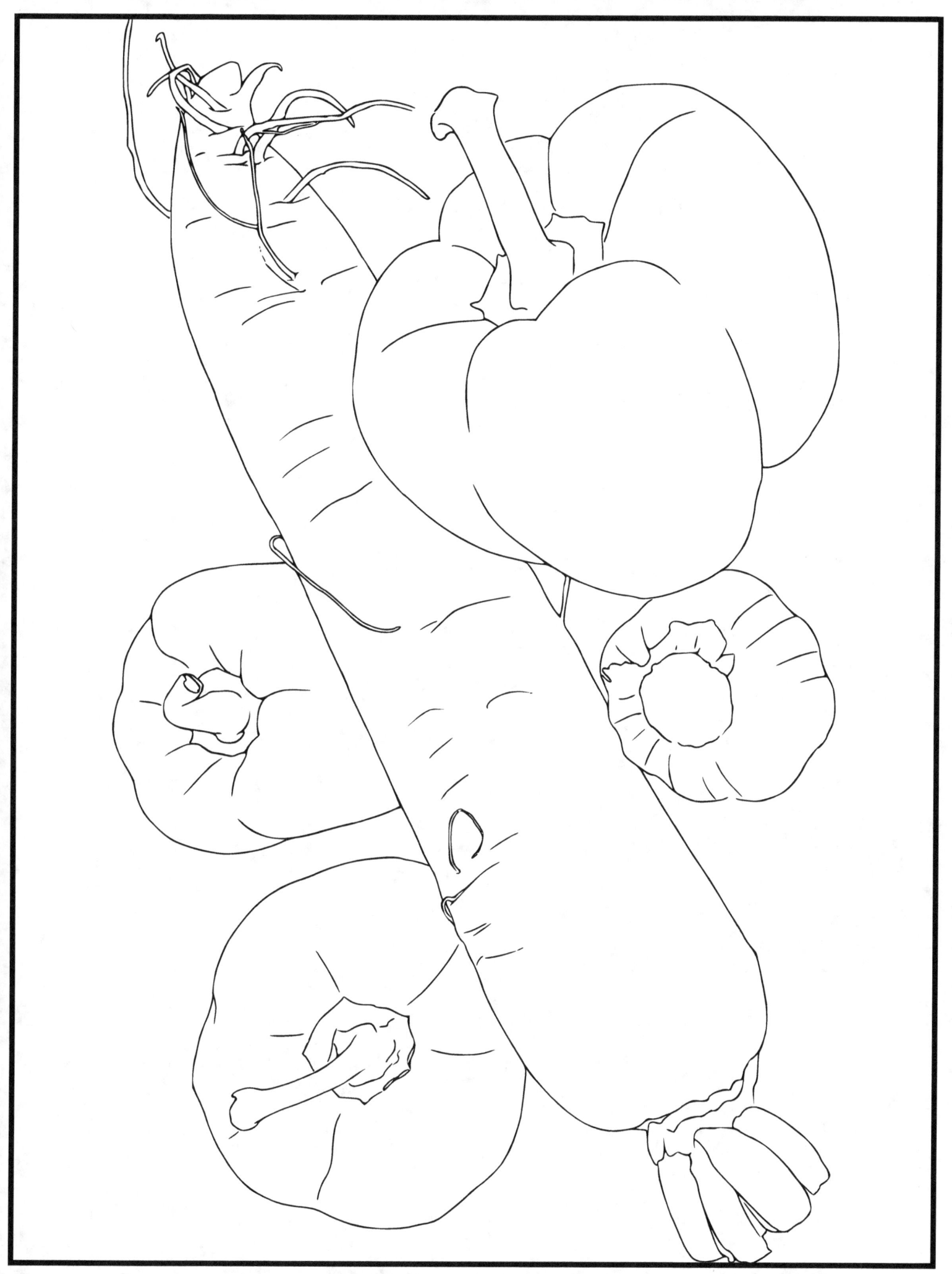

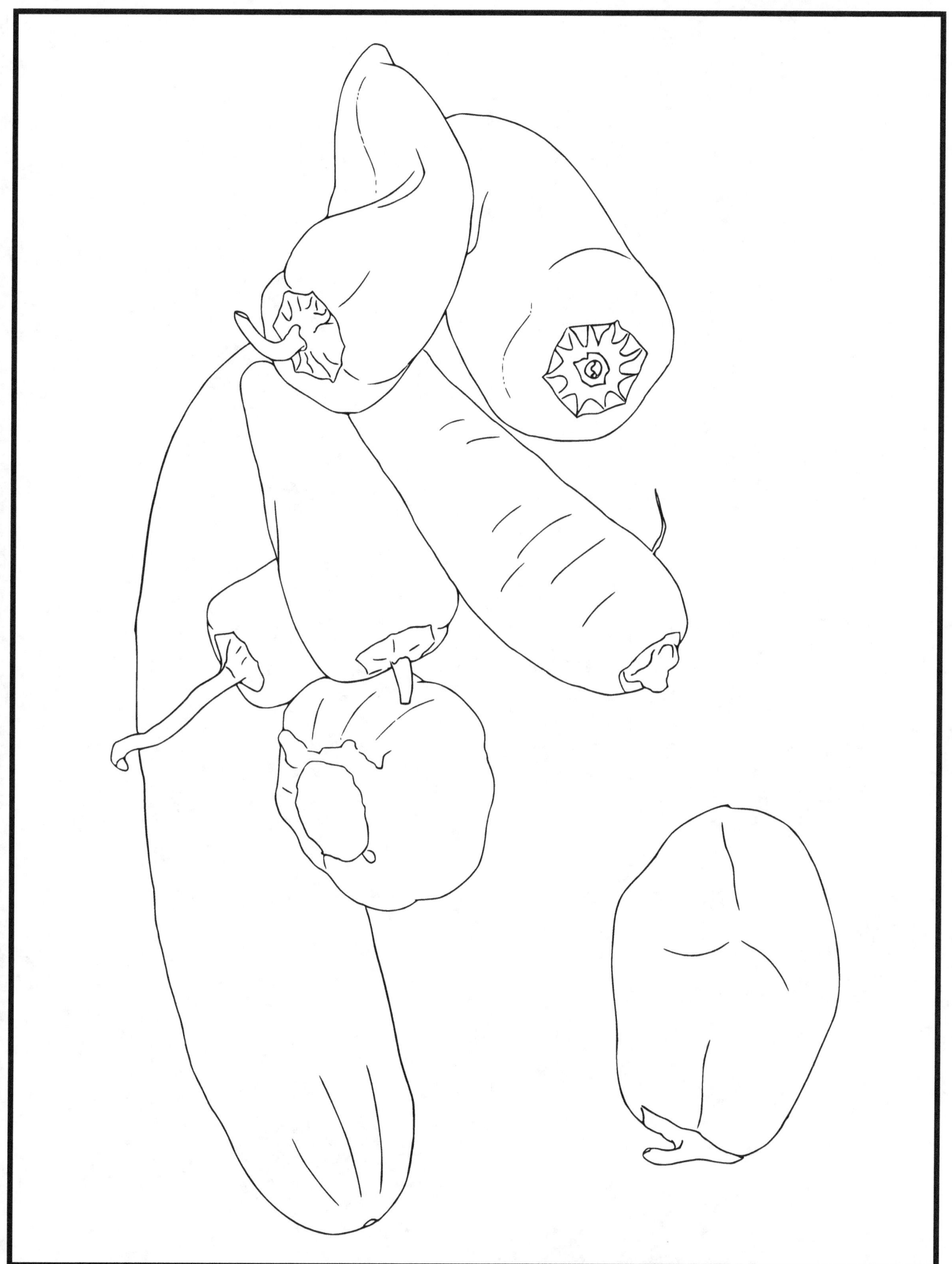

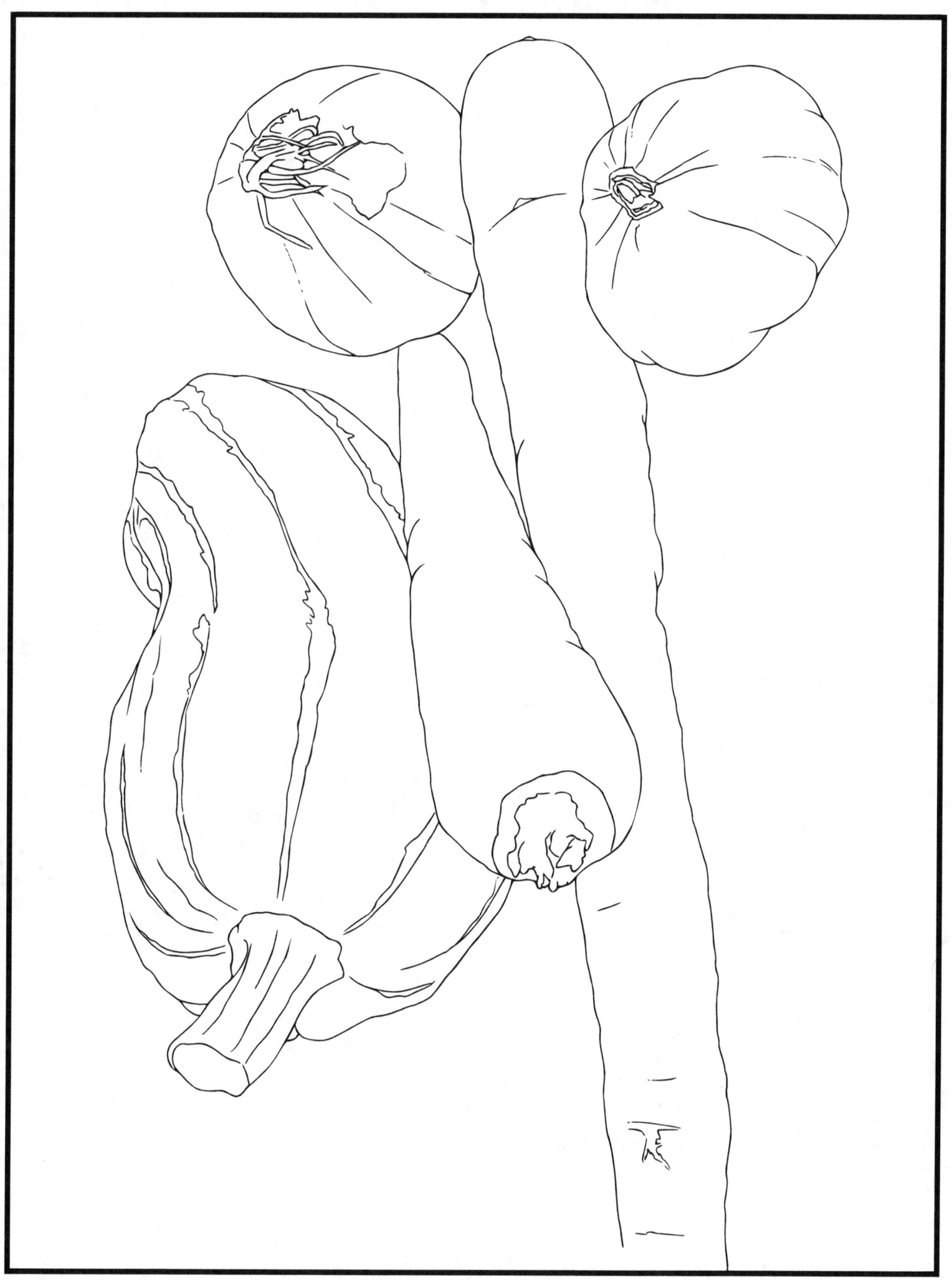

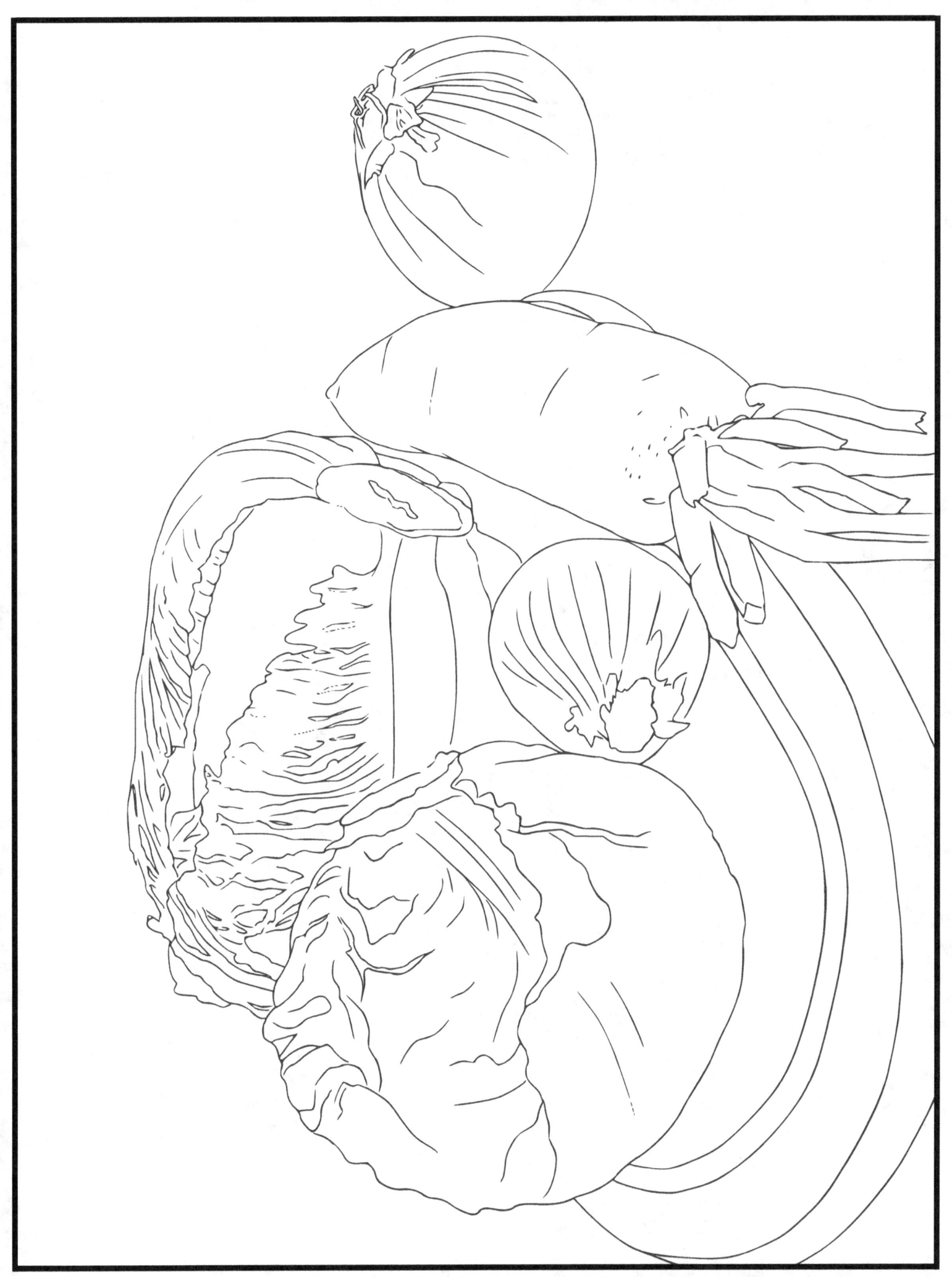

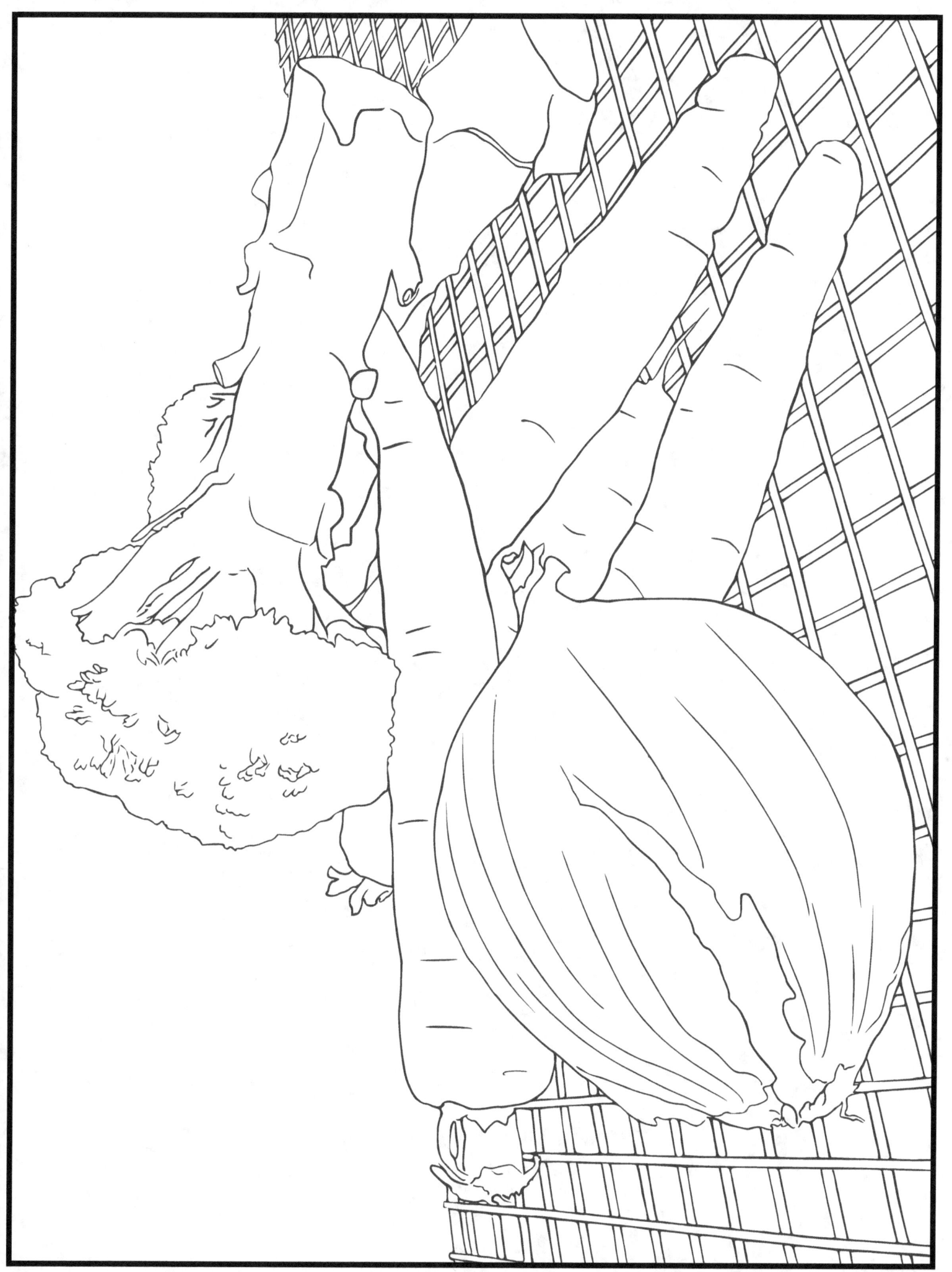

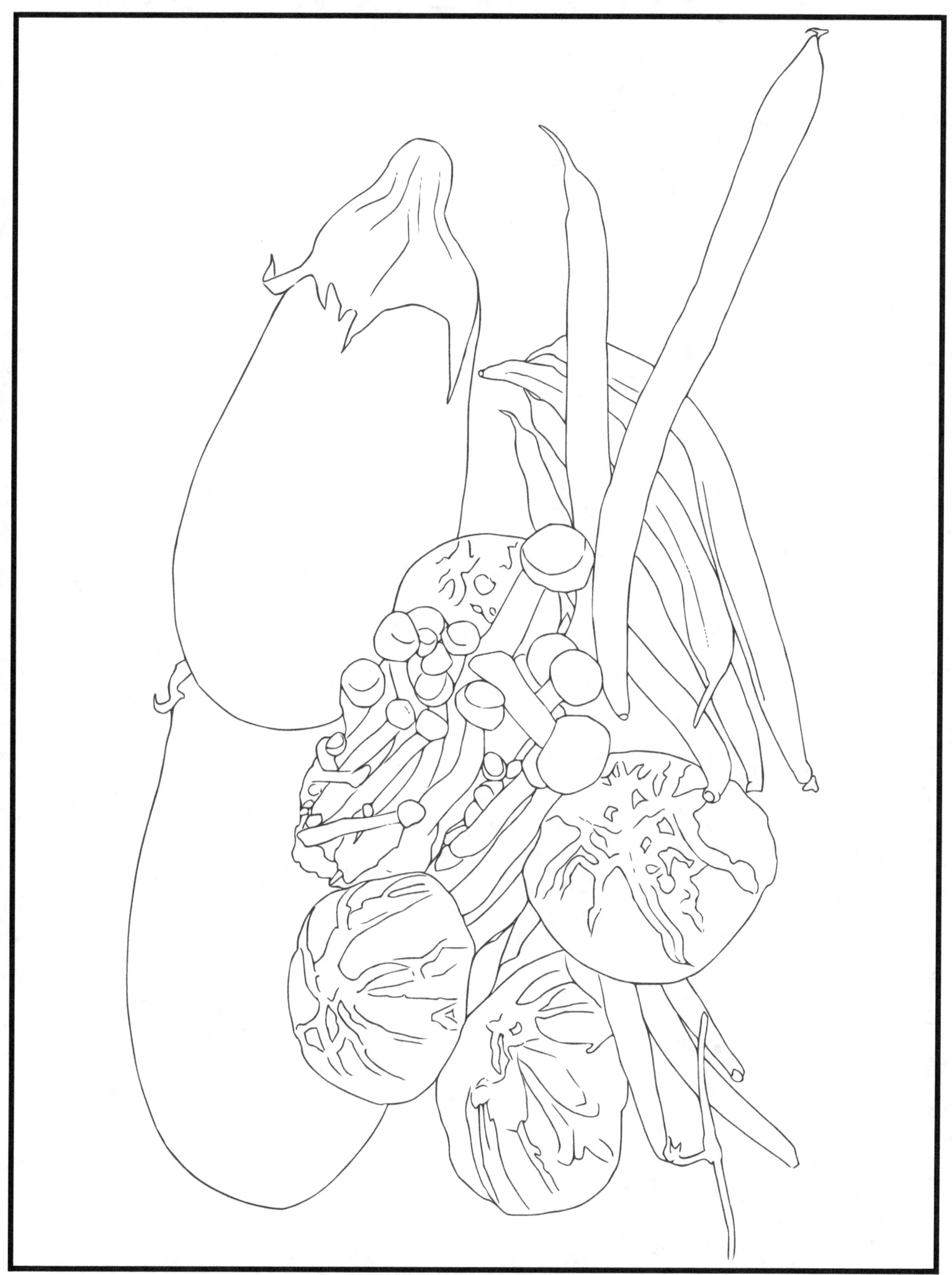

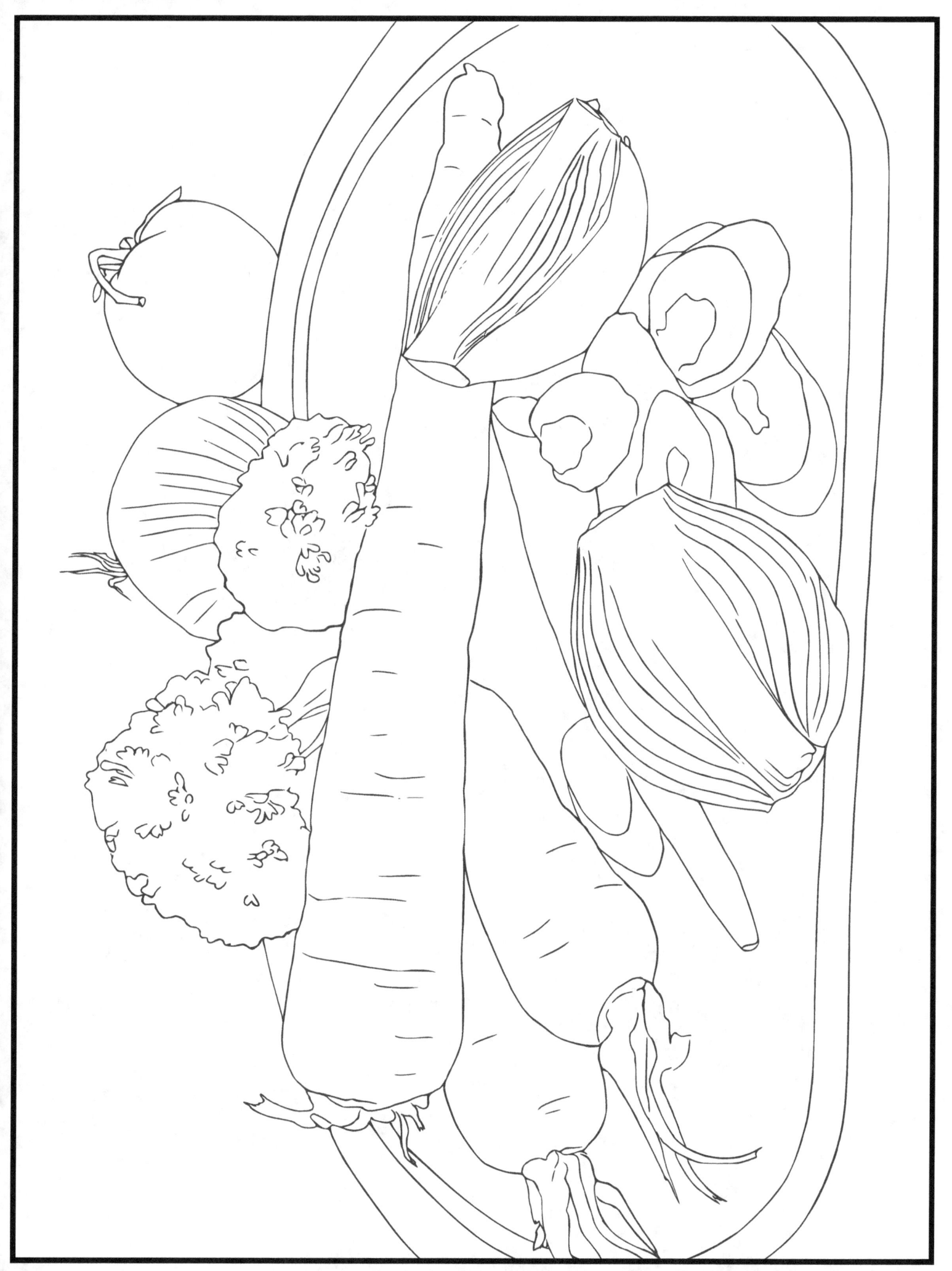

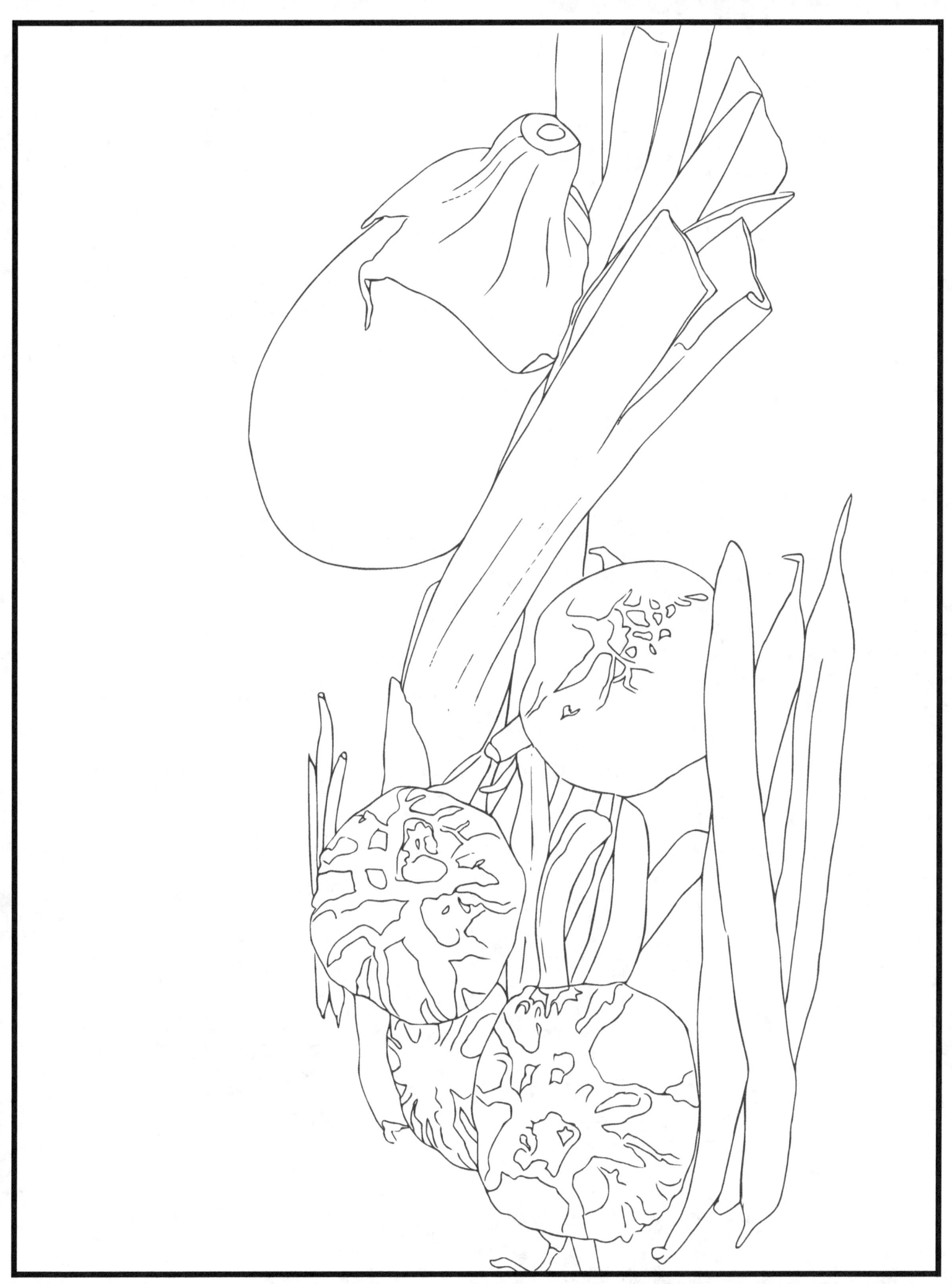

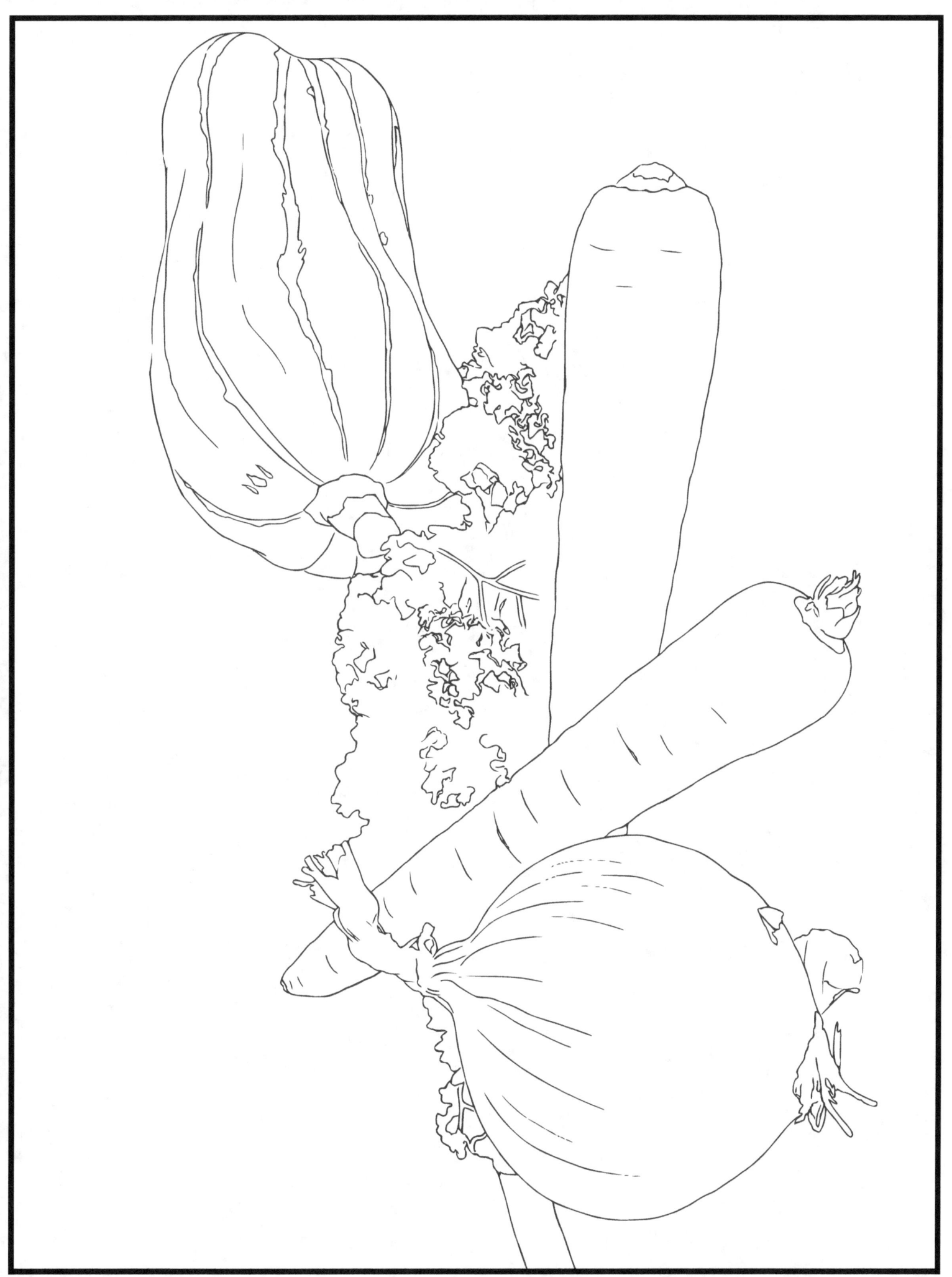

Color Test Page

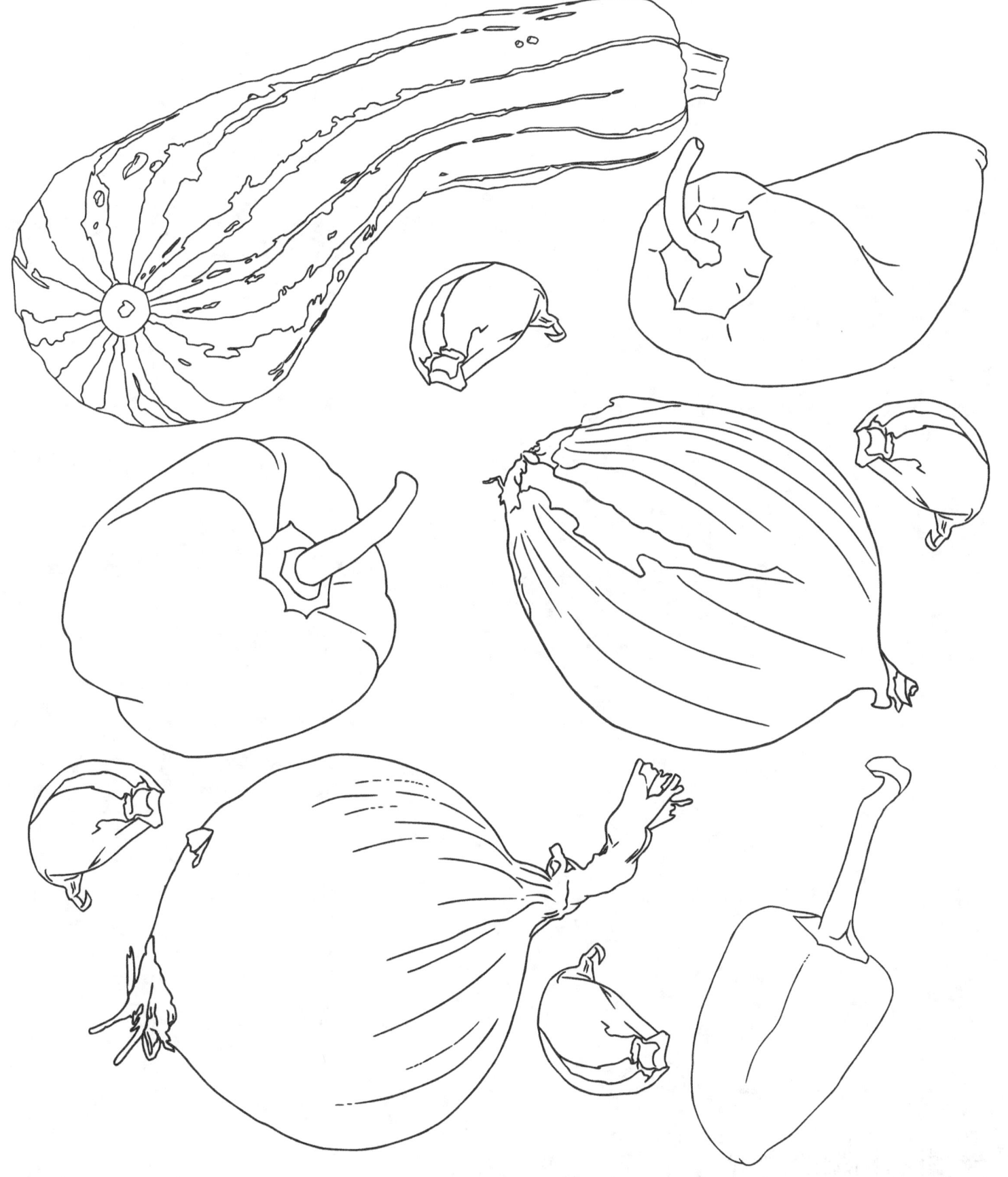

www.ingramcontent.com/pod-product-compliance
Lightning Source LLC
Chambersburg PA
CBHW081633220526
45468CB00009B/2413